EAST MEETS WEST

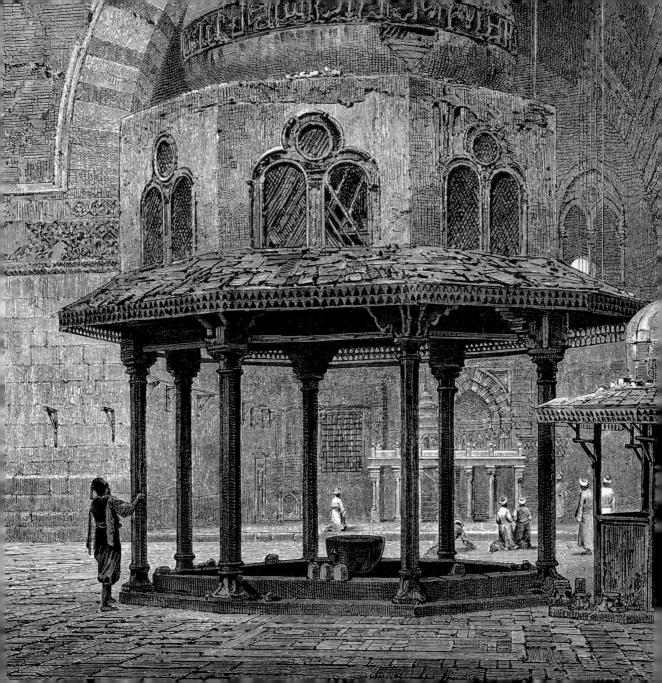

EAST MEETS WEST

The Crusades and the Age of Decolonisation

Edited by Martin Bommas

Macquarie University History Museum, Macquarie University, Sydney, NSW, Australia
in association with D Giles Limited

Macquarie University History Museum,
Macquarie University, Sydney, NSW, Australia

© 2021 Macquarie University

First published in 2021 by GILES
An imprint of D Giles Limited
66 High Street,
Lewes, BN7 1XG, UK
gilesltd.com

ISBN: 978-1-913875-02-2

For Macquarie University History Museum,
Macquarie University:
Project Manager: Martin Bommas
Project Coordinator: Georgia Barker
Photographs are © Effy Alexakis, Photowrite,
unless stated otherwise

For D Giles Limited:
Copy-edited and proof-read by Jenny Wilson
Designed by Alfonso Iacurci
Produced by GILES, an imprint of
D Giles Limited
Printed and bound in China

All measurements are in centimetres

Front cover: Sgraffito bowl (detail of fig. 31),
Byzantium, 12th–13th century, MU4642,
and sgraffito bowl (detail of fig. 23), Levant,
12th–13th century, MU4645
Back cover: Cairo, view of the citadel with
the pyramids in the background, looking
southwest (detail of fig. 19). H. Kretzschmer
(1871), in G. Ebers, *Ägypten in Wort und Bild*
I (Stuttgart/Leipzig, 1878), 317
Frontispiece: Inside the funerary complex of
Sultan Hassan (1356–63) (detail of fig. 18).
C. Werner (1871), in G. Ebers, *Ägypten in
Wort und Bild* I (Stuttgart/Leipzig, 1878), 305

A catalogue record for this
work is available from the
National Library of Australia

CONTENTS

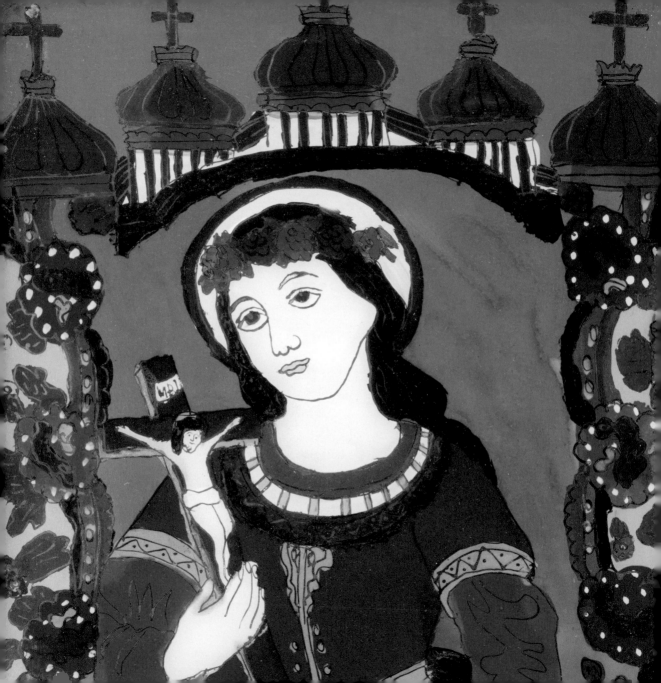

FOREWORD

The Crusades resulted in a series of wars of epic proportions. Between the end of the eleventh and the beginning of the fourteenth century CE, the 206-years-long conflict involved almost all European, North African and Middle Eastern countries, from Egypt to Mongolia. At the time, it comprised the largest world war planet earth had ever encountered: millions of people lost their lives, were sold as slaves or were otherwise de-rooted; empires emerged and collapsed; faith and religious beliefs were challenged as well as supported; and the impact of the divide between the East and the West still remains traceable today. Like the Great War and World War II, the Crusades changed the world forever.

What followed these years of crisis was a time for the restoration of order through changes in politics, trade and culture. In the West, the Catholic Church, and in particular Pope Urban II with his proclamation of the First Crusade in 1095, was held accountable for the Crusades, while secular leaders challenged the role of the Pope, thus paving the way for national monarchies in Europe. In the East, economy picked up pace and merchants in the Middle East found new outlets in Europe for products as varied as spices and oriental rugs, the sales of which were helped by the introduction of the credit system. Admiration for Islam and Arab literature and architecture fuelled the imagination of creative artists and art communities in Europe. However, only 45 years after the last crusade, the Black Death (or bubonic plague), which firmly held Europe and the Near East in its grip with a peak in Europe between 1347 and 1351, became the most fatal pandemic in human history, accounting for 75–200 million deaths and, to a large extent, a revision and replacement of the achievements made after the Crusades.

Icon of Mary holding the crucifix with Celestial Jerusalem in the background. Reverse glass painting in original wooden frame, Transylvania (Romania), ca. 1810, 22.5 x 32 cm (without frame). Private Collection, Sydney

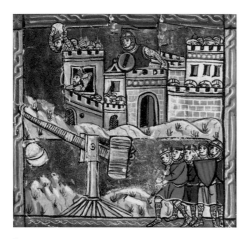

1
Siege of Acre during the Third Crusade.
Detail of illumination from *Histoire
d'Outremer* by William of Tyr, 'Saint-Jean-
d'Acre, Latin Kingdom of Jerusalem', 1280.
Bibliothèque Municipale de Lyon, Ms 828
f33r (wikicommons)

This new volume accompanies the opening of the Macquarie University History Museum in Sydney, Australia, in 2021, its inauguration delayed due to the COVID-19 pandemic. The Museum, with its extensive collections of artefacts ranging from the ancient Egyptian era through to modern-day Australia, has the human condition and social experiences over 5,000 years and on five continents as its focus. The Crusades forge a link between these two almost monolithic periods in the history of humankind, helping to translate the progression of antiquity to modernity. The wars' legacy is still felt today, even in a part of the world unknown to Crusaders: Australia. This book, accompanied by an exhibition of the same title, aims to bring this almost forgotten aspect of history to the memory of survivors of the recent COVID-19 pandemic, knowing that, although history itself is not repeated, patterns of history are. The violent escalations which erupted in East Jerusalem between the government of Israel and Hamas in May 2021 tragically follow such a pattern.

ACKNOWLEDGEMENTS

This publication has been made possible with support from the Monica Anderson Foundation for the Study of Ancient Cultures. We would also like to thank the private lenders who generously contributed artefacts to this book, as well as the exhibition, which have never been published or put on public display before. Special thanks are due, too, to the contributors to this publication: Mohamad Ali, Georgia Barker, Keagan Brewer, Louise D'Arcens and Bronwen Neil. Without the confidence and active engagement of Professor Martina Möllering (Dean of the Faculty of Arts), Dr Neil Durrant (Faculty General Manager), Janna Zeglis (Macquarie University Solicitor), Anna Grocholsky (Macquarie University Director of Commercialisation and Innovation), and the members of the MAC Board in 2019 and 2020, it would not have been possible to initiate and maintain the high level of exhibition and publication programming exemplified by *East Meets West*. Last but not least, we are indebted to Effy Alexakis at Photowrite for her artistic flair in producing excellent photographs, and Georgia Barker for her correspondence with contributors and lenders. Dan Giles and his team enriched this publication with their kind assistance and advice.

Martin Bommas
Museum Director

INTRODUCTION

Martin Bommas

When in the middle of the summer, on 15 July 1099, Jerusalem fell into the hands of 10,000 Crusaders who had fought their way up to one of Islam's most sacred sites, no one could have imagined the lasting impact that would be had when the East met the West. Eventually, after 206 years of fighting in the Eastern Mediterranean, the Crusades drew to a close. The Roman Church's attention moved away from what had been regarded as the Muslim menace and toward Christian reform movements and state building all over Europe, but not much had been won. What the historian Edward Gibbon (1737–1794) once called 'the world's debate' has largely come to be considered a debate between the deaf. Scholars have long argued that, while Muslim and Christian elites admired each other's religious fanaticism and warrior-like qualities, they failed to develop a lasting interest in each other's scholarship or art. But is this a balanced assessment? For Europe, the Crusades were a military failure but a cultural success. The series of wars established access to new trading markets, the development of engineering techniques such as ship-building and fortress construction, cross-cultural exchanges such as educational models that inspired European universities, and the exploration of distant shores, albeit often with the motive of financing the expensive wars (nonetheless, the travels of Marco Polo [1254–1324], for instance, coincided with the last Crusade wars). After the war and until the advent of the Black Death in 1346, peace and convergence was actively pursued on both sides, marking an Age of Decolonisation.

Ultimately, however, the West's failure to develop a balanced view on the Crusades has had a lasting legacy. On the one hand, Kaiser Wilhelm II (1859–1941) portrayed Saladin, who recaptured Jerusalem in 1187, as a paragon

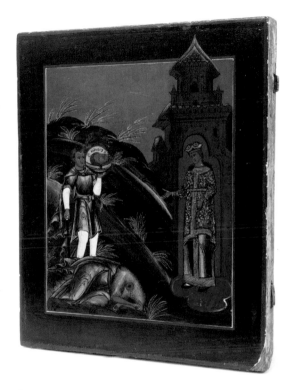

2
Icon of the Beheading of John the Baptist in front of the palace of Queen Salome. Some 500 years after the Crusades, this dramatic scene reinforces the divide between the West and the East by referring to cruelties against early Christians through eastern potentates. Egg tempera on wood, Russia, School of Palekh, ca. 1790–1800. 25 × 31 cm. Private Collection, Sydney

'All who die by the way, whether by land or by sea, or in battle against the pagans, shall have immediate remission of sins. This I grant them through the power of God with which I am invested. O what a disgrace if such a despised and base race, which worships demons, should conquer a people which has the faith of omnipotent God and is made glorious with the name of Christ! With what reproaches will the Lord overwhelm us if you do not aid those who, with us, profess the Christian religion! Let those who have been accustomed unjustly to wage private warfare against the faithful now go against the infidels and end with victory this war which should have been begun long ago.'

From Pope Urban II's speech calling for the First Crusade, after: J. Bongars, *Gesta Dei per Francos*, 1, 382–3, trans in O. J. Thatcher and E. Holmes McNeal (eds.), *A Source Book for Mediæval History* (New York, 1905), 513–17

of chivalric virtue; financed a magnificent tomb for him in Damascus; and became the first German emperor in 670 years to enter Jerusalem, riding in on horseback, dressed as a Crusader, during a state visit in 1898. On the other hand, the schism between Islam and Christendom has been described by the highly regarded Lebanese writer, Amin Maalouf (b. 1949), as dating back to the Crusades, which he characterizes as 'an act of rape'. Jerusalem is still a place all religions claim to own, with Christians, Muslims and Jews all finding it equally hard to co-exist in peace. In 1978, US President Jimmy Carter managed to bring together Israeli Prime Minister Menachem Begin and Egyptian President Anwar el-Sadat to sign the Camp David Accords, which aimed to increase hopes of solving Israeli-Arab conflict. Shortly afterwards, Carter failed to get re-elected, partly because it proved to be impossible to force Iran to return American hostages. President Sadat, together with ten others, was assassinated by Muslim extremists in 1981. Menachem Begin was widely condemned by secular Jews for handing back the Sinai Peninsula to Egypt in 1982, which in their view contradicted the Greater Israel agenda.

In Australia, the term 'crusade' has generally enjoyed a positive connotation. Billy Graham's Evangelistic Crusade of 1959 is still remembered as a nation-wide event that drew more than 3 million people, nearly a third of Australia's population at the time. Since 1930, the Crusader Union has proclaimed 'the gospel of Jesus to school students in NSW, the ACT and WA'. Meanwhile, a big Japanese car manufacturer sells a popular off-road model called Crusade. The list continues... However, since the 1960s, 'crusades' have also been implicated in critiques of colonialism and Western intervention, including acts of racism. While President Harry S. Truman provoked hardly any criticism for his proclamation of the 'crusade against communism' (1947), George W. Bush's 'crusade on terrorism' in 2001 rang alarm bells, especially in Europe.

In the fourteenth century, after the Crusades ended, large parts of the world embarked on an enterprise that overcame more than 200 years of crisis in an

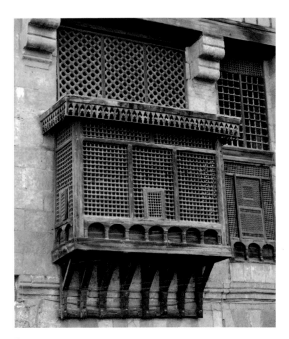

3
Abu al-Dhahab mosque, Cairo, with a bay window displaying wooden *mashrabiya* screens. Copyright: E. Khalifa

4
The Wikala of Sultan Qansuh al-Ghuri (1504–5), opposite Al-Azhar mosque, Cairo, is the best-preserved commercial hotel from the Mamluk period. When it was built, Cairo was still the world's trading hub for oriental merchandise, such as spices. However, shortly before the *wikala* was established, the Portuguese had discovered an alternative route to the Indian subcontinent around the Cape and across the Indian Ocean, threatening trade in the Middle East. Copyright: E. Khalifa

unprecedented understanding that inspired tolerance, respect, world trade, knowledge transfer and cultural exchange in areas as diverse as literature, garden design and architecture. In Renaissance Art, oriental objects such as rugs were included to represent the East as early as 1486 as shown in Carlo Crivelli's painting The Annunciation, with Saint Emidius (National Gallery London NG 739). It was a period of hope and learning. It continues to inspire and facilitate the dialogue between the East and the West.

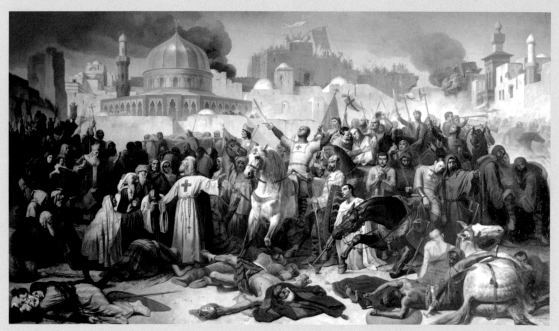

5
Émile Signol, *Taking of Jerusalem by the Crusaders, 15th July 1099*, 1847, oil on canvas. Palace of Versailles, France

THE CRUSADER PERIOD AND MEDIEVAL UNDERSTANDINGS OF THE EAST

Keagan Brewer

The Crusader period saw the first grand-scale encounter between Western Europeans and non-Europeans in many centuries, which altered European society indelibly and in complex ways. In 1095, Pope Urban II proclaimed the First Crusade, which marched towards Jerusalem with great trial and tribulation, and against all odds conquered it in 1099 (fig. 5). Jerusalem had been for centuries a place visited by European pilgrims, and the contemporary Latin terminology for the crusade used words similar to the English 'pilgrimage', 'road' and 'path'. Jerusalem,

where Christ had walked, was of profound importance to medieval Christianity at a time when faith figured highly. The city was the centre of many contemporary world maps (*mappae mundi*), the symbolic link between earth and heaven, and a destination for spiritual tourists. However, when thousands upon thousands of European knights, prostitutes, lords, farmers, monks, entertainers and priests entered Jerusalem in 1099, fired up by devotion and a centuries-long vilification of Muslims, they not only engaged in a horrifying massacre of many of Jerusalem's inhabitants,

but also unwittingly set up one of the earliest colonial experiments of European society.

The establishment of the Crusader states in parts of today's Israel, Lebanon, Syria, Jordan, Turkey and Cyprus brought European norms and ideas into contact, and often conflict, with Middle Eastern cultures in all their breadth and profound diversity. The Kingdom of Jerusalem, for instance, was one of Catholics superimposed upon local Muslims, Christians and Jews – including nomads. Following the norms of medieval feudalism, subalterns could not access power or lordship. Even other Christians (Byzantines, Melkites, Georgians, Armenians, Nestorians or Jacobites) were denied access to power. Nevertheless, there was assimilation in addition to domination. Even as early as the 1120s, one of the First Crusade's participants, the cleric Fulcher of Chartres, famously wrote that 'we who were occidentals have become orientals'. When a Muslim diplomat named Usāmah ibn Munqidh visited decades later, he found those who had recently arrived from Europe to be rude and aggressive. One attacked him for praying southwards towards Mecca rather than eastwards, as was the European custom. The local Franks, Usāmah says, were friendlier. He even reports a remarkable tale of nude public bathing which he had heard from his friend Salim, who owned a bathhouse. In it, a Frankish knight became amazed upon seeing Salim's shaved pubic hair, and then requested the same for himself and his lady, which Salim performed to the man's great satisfaction. In 1187, when Salāh al-Dīn (Saladin) conquered Jerusalem, European writers including Pope Gregory VIII and Peter of Blois claimed that God was punishing the kingdom for excessive integration with local customs. Officially at least, the kingdom was at war with Muslim polities for most of its existence, including forays against Egypt and even a scouting raid towards Mecca. At the same time, European science and philosophy progressed greatly through contact with Muslims in Spain, Sicily, and to a lesser extent the Levant, particularly because writers beyond Europe had preserved in various languages Aristotelian writings that had been lost in Western Europe.

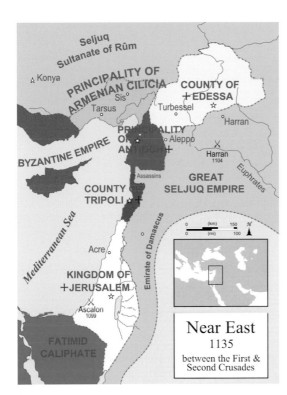

6
Political map of the Near East in ca.
1135 before the Second Crusade
(public domain)

Contact with the Near East (fig. 6) also allowed people of European heritage an opportunity to reconsider East Asia. By the time of the First Crusade, contacts with Asia had been few and far between, or non-existent, for a millennium. Vikings such as Ingvar the Far-Travelled journeyed into Serkland, thought to refer to Muslim-majority territories. Silk, gold, gemstones and spices were traded from India, Afghanistan, China and elsewhere through to Europe via a network of profit-seeking intermediaries (fig. 7). Evidence for direct contact between Europeans and East Asians between Attila's invasions in the fifth century and the thirteenth-century Catholic missions to the Mongol khans is rare and problematic. One instance is an embassy in the ninth century from King Alfred the Great of England to 'India', a term of loose meaning to medieval Europeans. In the absence of direct contact and experience, Europeans took authority from classical and biblical mythologies. European world maps therefore depict Asia using tropes such as the Plinian monsters, the garden of Eden, and the Satanic tribes of Gog

7
Mamluk coinage, Ismail II (r. 1342–6),
Hamah mint, 3.62 grams; obverse, legend
within double lined rectangular frame;
reverse, field with two lines of legend within
circular border. Bahri Dynasty, 1342–6,
diam. 2 cm. U448

and Magog, which, according to the popular medieval legend of Alexander the Great, Alexander had locked behind distant mountains until judgement day.

A major development came with the rise of the Prester John legend. In 1122, a mysterious stranger named John, who claimed to be from India, arrived at the curia of Pope Callixtus II in Rome. It is impossible to tell from the sources whether he was actually from India, nor whether he was a legitimate

dignitary or a daring impostor. John claimed his kingdom was in disarray and that it needed a new prince. He recounted stories about the miracles of St Thomas the Apostle, whose body, so he claimed, rested in India and revivified annually to bestow magnificence upon the people. Callixtus allegedly believed John's tale. Then, in 1145, report of a large-scale battle near Samarkand between the Seljuq sultan Sanjar and Yelü Dashi, leader of the Kara-Khitai, reached the Crusaders in Antioch. This grand meeting of civilisations ended in a profound defeat for the Muslim Seljuqs at the hands of the semi-nomadic warriors of the Central Asian steppes. In Antioch it was reported that Yelü Dashi was a Christian, and this inaccurate depiction reached Pope Eugenius III in Rome. These two events gave rise to one of the most powerful and enduring legends of European history, that of a mighty and affluent Christian ruler somewhere off in the Far East with whom Europeans could ally if only they could locate him. Around 1165–70, an anonymous European wrote a letter purporting to be from Prester John. A landmark of imagination, the letter is an orgiastic feast of the monsters, magic and opulence with which Europeans had associated India for centuries. The letter survives in almost 500 medieval copies, and was quickly translated into languages as far afield as French, Hebrew, Russian, Danish, Serbian, Irish, and more. A letter of ca. 1177 has Pope Alexander III attempting to make diplomatic contact with 'John, king of the Indians', strangely via his doctor, a 'Master Philip' about whom nothing is known. Over the following centuries, even though Prester John never existed (at least not in the way he was imagined to), European commentators identified him in Mongolia and later Ethiopia, as Chingis Khan or the head of the Nestorian Church or the Dalai Lama, and even later as leaders in Mozambique or the African interior.

Legends like that of Prester John evoked wonder, curiosity, fear and horror at Asian cultures, which – along with practical concerns of diplomacy, politics and trade – sent large numbers of Europeans eastwards. Following the rise of the Mongols and the consequent eastward shift of power in the thirteenth century, we find Europeans in Iraq, Central Asia, India,

Mongolia, China, and elsewhere. One of the earliest missionary reports by a European who visited Mongolia says that there were already European glassmakers and smiths there. Missions and diplomatic efforts are better preserved in the historical record than the adventures of craft workers. However, diplomacy was often conducted poorly and therefore fruitless. Giovanni da Pian del Carpine, one of the early missionaries to the Mongols, for instance, carried a letter from Pope Innocent IV requesting peace, apparently unaware that the terms for 'peace' and 'submission' are similar in the Mongolian language; the newly crowned Güyük Khan sent Giovanni back with a haughty letter demanding the submission of the pope and all European kings to Mongol authority. The khans were religiously pluralistic and held debates between Jews, Muslims, Catholics and Nestorians at court, but Catholic missionaries were never able to lastingly convert them. The correspondence of Giovanni da Montecorvino, a Catholic missionary to China in the late thirteenth century, reveals a subtle sorrow at his lack of achievement. Even in the twelfth and early thirteenth centuries, daring evangelists

travelled to the Middle East hoping to convert Muslims; one case is the famous encounter between St Francis of Assisi and al-Kāmil, Ayyūbid sultan of Egypt. The anonymous English author of the *Latin Continuation of William of Tyre* wrote that if the Third Crusade had been successful then Europeans could have conquered India and all the known world, but this grandiose vision was never a legitimate policy aim. Although the destruction of Islam was a topic of frequent discussion in the central Middle Ages, debate raged not about whether it should be done, but whether by evangelism or the sword.

Travel literature played an important part in perpetuating stereotypes about Asia that contributed to the European exploratory impulse. While the more prosaic and accurate accounts like William of Rubruck's ethnographic treatise on the Mongols were copied infrequently, the more embellished and mendacious accounts like those of Marco Polo or John Mandeville proved more popular. These depicted Asia as a land of aberrant sexuality, femininity, hybridity and monstrosity. Travel from East Asia to Europe was much

more infrequent than its opposite, of which
only a few instances are recorded, such as the
travels of Rabban bar Ṣawma in the late thir-
teenth century. The Crusader period was
thus an important step in the development
of European curiosity about East Asia, which
arguably only developed later into a desire to
dominate and exploit. In 1487, King João of
Portugal sent two explorers (Pêro da Covilhã
and Afonso de Paiva) eastwards with the dual
aims of finding the origin of cinnamon and the
seat of Prester John. Christopher Columbus
carried a copy of Marco Polo's *Travels* in his
search for India, which he 'found' in 1492 in
the Caribbean islands.

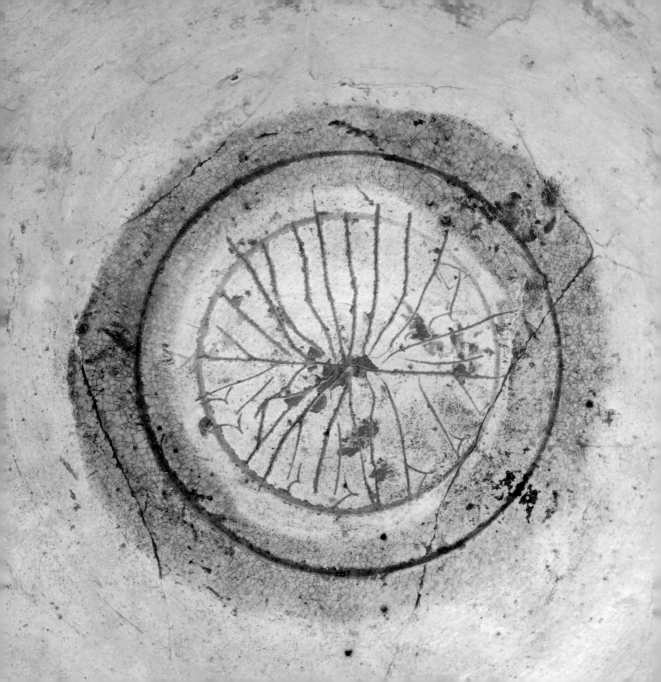

THE BYZANTINE EMPIRE

Bronwen Neil

Byzantium – or Constantinople, as it became known after its founder, the emperor Constantine I (r. 306–37) – was the centre of what became the Byzantine empire, covering a vast territory at its peak in the sixth century.

THE BEGINNINGS OF NEW ROME

The Byzantine empire was based on the rebuilding of the Greek city of Byzantium and its subsequent founding as the 'New Rome' in 330. The city had been razed in 193–5 by Septimius Severus and reduced to the status of a village, but its location on the peninsula between the Propontis and the Golden Horn at the Bosporus (modern Turkey) gave it the capacity to control the shipping trade. This natural advantage made it a prime candidate for the capital of a new Christian empire under Constantine I.

Son of the general and tetrarchic emperor Flavius Constantius (one of two rulers of the western Roman empire), Constantine was the first Roman Caesar to adopt Christianity. This faith had quickly spread from Palestine to Rome in the first century and achieved a high level of popularity across the Mediterranean in the first three centuries. Constantine believed that he owed his success in defeating his rival Maxentius at the Battle of the Milvian Bridge in 312 to a vision of the cross or the first two letters of Christ's name (Christos meaning

'anointed one') and a divine command to 'Conquer under this sign'. His victory allowed him to march into Rome and eventually, in 324, to become sole emperor of the united eastern and western Roman empire.

Constantine's lengthy rule was based on the idea that he had been chosen to represent God on earth. Constantine was a native Latin speaker but learnt the rudiments of Greek, as befitted an eastern emperor. Even in the ninth century, Byzantine rulers called themselves in Greek 'Romaioi' (Romans) and thought of themselves as the rightful continuators of the Roman empire. Constantine and his dynasty's sound rule and prosperity needed to be fortified by prayers of the clergy. The number of Christians grew exponentially from the late fourth century, with many imperial benefactions to churches and a state-subsidised clergy.

CODIFICATION OF BYZANTINE LAWS

Even though Christianity became a legal Roman religion only under Constantine, with the Edict of Milan in 313, it quickly became the sole legal religion under various decrees issued by Emperor Theodosius I between 380 and 391, which outlawed paganism. Theodosius reinforced his agenda by summoning all bishops to a second ecumenical church council in 381, which issued a number of canons or rules. One of these was to prove controversial because it gave the bishop of Constantinople the highest status after Rome, 'because Constantinople is New Rome' (Canon III). The unification of the whole empire under one faith called for the issue of a new legal code, where all previous edicts were gathered in one place. This was the Theodosian Code, named for Theodosius II who had it compiled during his reign and issued in 438.

Byzantine society was strictly hierarchical. From the time of Justinian (r. 527–65) the collection of all previous edicts in three books, together known as the Justinian Code, allowed

emperors, civil servants, the military and the clergy to maintain social order and clerical discipline. Power was centralised in the imperial court, which was closely linked to the military: many emperors were former generals or their sons. Their female relations had an important role to play in keeping orthodoxy visible, with the aristocracy and the upper echelon of clergy close behind them. The founding of exarchates – imperial provinces with governors in Ravenna, Sicily and North Africa (Carthage) – also ensured that Byzantine officials controlled the western reaches of the empire that were reclaimed by Justinian's 'restoration'.

BYZANTINE LITURGIES AND CHURCH ART

Byzantine Christianity was intimately tied to the Roman imperial cult which had pre-existed it. Its religious services aimed to imitate an imagined heavenly act of divine worship. Byzantine church services or liturgies, first sung in Greek, were splendid to behold.

Russian ambassadors who travelled from the court of Prince Vladimir in Kiev in the tenth century to witness the splendour of the main church of Hagia Sophia (Holy Wisdom) were overwhelmed and confused: 'We did not know where we were, in heaven or on earth', they reported to their monarch. The liturgy of the Byzantine rite was celebrated in Georgia, Syria, Armenia, the Balkans, Russia and Ukraine. Byzantine religious art was mostly representational, and its rich frescoes, icons and glittering mosaics were widely copied. Master craftsmen travelled from the Byzantine East to Venice to recreate the Byzantine style in the Basilica of St Mark's, and to Sicily to do the same for the Norman rulers of the eleventh century.

The cruciform design of Byzantine churches, with an apse, a long nave and two chapels, one on either side halfway down the nave, made it ideal for decoration. The apse and multiple wall panels carried images of Jesus, Mary and other saints, illustrating their lives and their miracles, in paintings on plaster (*freschi*) and mosaics of tiny cut-glass tiles (*tesserae*).

8
Embossed gold leaf pendant (?) from a diadem.
This gold leaf may have formed the centrepiece of
a diadem such as one shown opposite or may have
hung from a diadem by a fine chain. Macedonia,
Greece, ca. 300–200 BCE, 2.5 × 3 cm. MU2880

The communion of saints also played
an important part in domestic settings, with
icons of Mary and other local saints gracing
most households. These saints were revered
as intercessors for souls after death and as
miracle-workers for the living. Their powers
ranged from healing infertility to punishing

adulterers and prostitutes. Every aspect of
life was covered by one saint or another, as
the Byzantine litany of saints attests. Each
newborn child was named for a saint and
celebrated their namesake on their 'name
day', a practice which continues in Orthodox
societies to this day.

THE BYZANTINE COURT

The Orthodox faith of the imperial family was
the firm foundation of social order and pros-
perity, with both emperor and patriarch of
Constantinople commanding a level of respect
that was considerable. Even so, conspiracies,
usurpations and violent deaths were common
in the court, and the intrigues of court
eunuchs were renowned.

The elaborate ceremonial of the Byzantine
court was also influenced by religious rituals,
as outlined in Constantine Porphyrogennetos'
Book of Ceremonies (10th century). The use of
gold thread and purple dye for imperial robes
and silks emphasised the wealth and status
of the wearer. Emperors and their wives and

9
Byzantine diadem of gold sheet with bust of a saint and four scenes in which Christ hands over a cross to an apostle, the codex to Paul, a cross and orb (?) to the emperor, and crosses or swords to saints. Byzantium, 1100–50, L: 12.5 cm. MU4576

10
Triangular embossed gold diadem with symmetrical floral design. Hellenistic embossed gold sheet strongly influenced Byzantine craftsmanship. The diadem was fixed on the head with a leather strap fastened to the diadem at either end. Northern Greece, Hellenistic, possibly 300–200 BCE, L: approx. 20 cm. MU3638

9

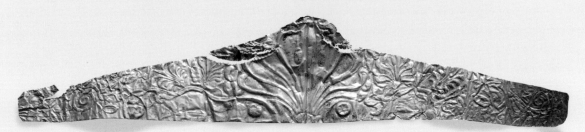

10

11
Diam. 8.9 cm, W: 0.9 cm. MU4656

12
Diam. 9.1 cm, W: 0.7 cm. MU4657

11–14
Bracelets, polychrome glass with remains of silver staining. The silver staining techniques were developed in Egypt during the 8th century and adopted from the Arab world in the middle Byzantine Period. Byzantine/Islamic, 1100–1400

heirs are depicted in manuscripts, on coins and in mosaics adorned with necklaces, earrings, and diadems embedded with gems and pearls and crafted out of precious metals (figs. 8–10). Members of the elite imitated imperial ornamentation with textiles and jewellery of lesser quality, such as polychrome glass bracelets

(figs. 11–14). The collection of the Macquarie University History Museum preserves some important pieces of Byzantine material culture, such as the sgraffito pottery described in this volume (figs. 15, 22–24 and 31) and a gold diadem depicting saints and the cross (fig. 9).

THE BYZANTINE EMPIRE

In the ninth century, the Byzantine church expanded its jurisdiction to include Bulgaria. The Khan of Bulgaria, Boris, adopted Michael

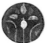

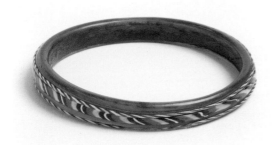

13
Diam. 9.1 cm, W: 0.8 cm. MU4658

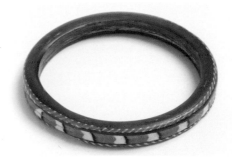

14
Diam. 8.4 cm, W: 0.7 cm. MU4659

as his Christian name when he converted to Orthodox Christianity and was baptised in 864. Although ecclesiastical jurisdiction over the Balkans was hotly contested by the church of Rome, the Greek church was successful in its missionary endeavours in all the Balkan territories apart from Dalmatia.

Byzantine culture, as well as being highly artistic, was highly literary. Manuscripts in Greek, Latin, Syrian, Old Church Slavonic, Georgian and Armenian show the vast range of literary genres and geographical coverage of Byzantine letters, novels, poems, panegyrics, homilies, hagiography, dream manuals, medical tracts and other scientific treatises.

The walls built by Constantine protected his capital city for over 1,000 years. An important ingredient in Byzantine military success was the development of a weapon known as 'Greek fire', 'sea fire' or 'Roman fire'. A combustible compound was set alight and hurled by a flame-thrower over city walls or from Byzantine ships at the enemy fleet. This weapon saved Constantinople in the first and second Arab sieges in 674–78 and 717–18. The walls of Constantine's city finally fell in 1453,

when the Ottomans at last managed to breach them on 29 May after a 53-day siege.

After the fall of Constantinople, many Greeks took up residence in the Fener district, named for the Greek word for 'streetlight' or 'lightpost' (*fanarion*). Although the city was conquered, a Greek patriarch continues to reside in Istanbul at the patriarchal palace at Fener, and the original patriarchal library is preserved there, as well as the Byzantine Cathedral of St George. Other churches of note that are still standing are Hagia Sophia and the Chora church, both converted to Islamic museums but with some of their original mosaics intact.

15
Small sgraffito bowl with green underglaze, painted and engraved decoration with a medallion in the centre, ring foot. Eastern Mediterranean, 12th–13th century, 4.8 × 19.3 cm. MU4646

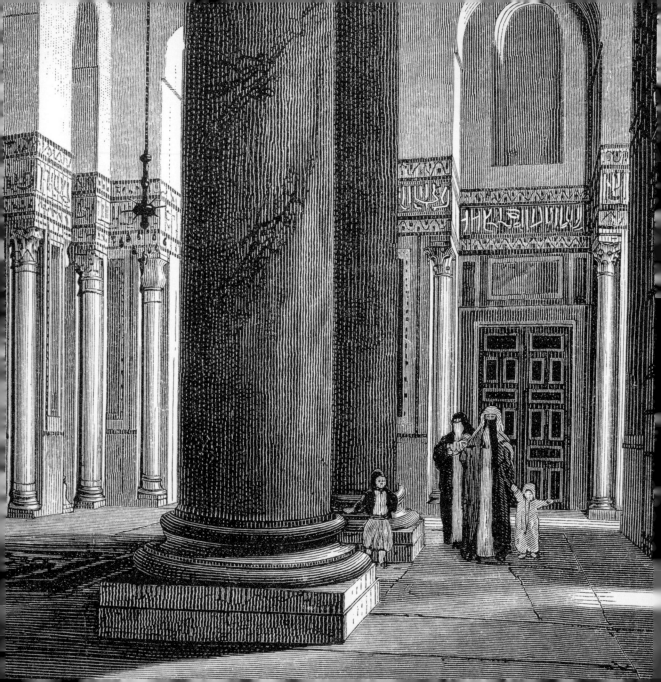

THE INVENTION OF SKYSCAPE: MAMLUK ARCHITECTURE IN EGYPT DURING THE 13TH AND 14TH CENTURIES

Martin Bommas

'I arrived at length at the city of Cairo, mother of cities,
mistress of broad provinces and fruitful lands,
boundless in the multitude of buildings,
peerless in beauty and splendour.'

Ibn Battuta, *A Masterpiece to Those Who Contemplate the
Wonders of Cities and the Marvels of Travelling*, 1345

The advent of the Mamluk Sultanate in 1250 during the Seventh Crusade (1248–54) was not a surprise event. The Mamluks' presence changed warfare forever. They were a caste of elite slave soldiers – the word mamluk meaning 'one who is owned', or 'slave'. Young men were brought to Cairo from Christian lands, especially the Eurasian steppe and the Caucasus. Non-Muslim boys and adolescents were converted to Islam and trained in military arts and the highest standards of warfare, loyal to their masters who physically owned and trained them. Once indoctrinated and devoted to the state and religion, the mature

Mamluk was given freedom and introduced to the highest ranks of the ruling class. As the ultimate warriors, they engaged in their first battle in 1249, defeating the army of King Louis IX of France in the centre of the city of Mansourah in 1250. Under Sultan al-Zahir Baybars I, the Mamluks went on to drive hordes of Mongols out of Arab lands in 1260, blocking their quest for practical dominion, which had become the biggest threat to Islam. The Mongols made several re-appearances in Syria, but their defeat in 1260 ceased the myth of Mongol invincibility.

The Mamluk Sultanate resided on the island of Roda in a palace close to the Nile (al Bahr, 'the sea'), which lent its name to the Bahri dynasty of Mamluk sultans (1250–1383). Having defeated the world's strongest armies in 1250 and 1260, the Mamluk Sultanate maintained Egypt's control over Syria, drove the Crusaders off the Nile Delta, and repelled four Mongol attacks on Egypt. With Cairo being a wealthy crossroads of trade, the rulers were able to maintain an efficient army, especially trained in hand-to-hand combat, and subsidise learning, the arts and architecture with their own new visions.

MONUMENTS OF THE BAHRI DYNASTY

One hundred monuments of the Bahri dynasty are known in Cairo, as documented in the *Index to Mohammedan Monuments in Cairo* in 1951. Of these, the mosque of Baybars I, the complex of Sultan al-Mansur Qalawun, the monuments of al-Nasir Muhammad, the mosque of Amir Altinbugha al-Maridani and the *madrasa* of Sultan Hassan are the most important. The period between 1263 and 1363, during which time these monuments were built, marks the formative years of Mamluk architecture, which turned Cairo into 'a city beyond imagination', as described by Ibn Khaldūn (1332–1406), scholar of Islam and founder of modern historiography.

Of these, the earliest monument, the mosque of Baybars I (r. 1260–77), is situated outside the urban centre, north of the modern Attaba Square, at El-Zaher Square. Finished as an arcaded congregational mosque in 1269, its building material included stone columns collected from all over Egypt. The mosque's dome was

16
Inside the mausoleum of the funerary complex of Sultan al-Mansur Qalawun (1284–5), looking south with the *mihrab* pictured on the left. Artist: J. Machytka (1871), in G. Ebers, *Ägypten in Wort und Bild* I (Stuttgart/Leipzig, 1878), 291

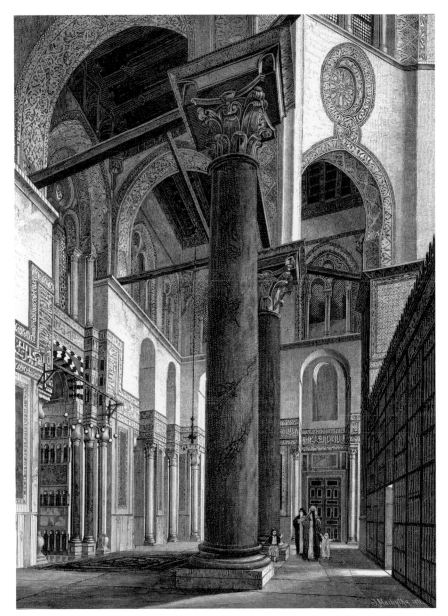

originally built from timber and marble that Baybars I had seized from the Crusaders in 1268 when he captured their citadel at Jaffa. Staying true to the preceding Ayyūbid dynasty tradition, Baybars I also constructed a *madrasa* in 1263.

The complex of Sultan Qalawun (built 1284–5) consisted of a hospital and madhouse, a *madrasa* and a mausoleum (demolished in 1910; fig. 16). The hospital, an unparalleled achievement of the time, offered its services to all Muslims – men and women, rich or poor, from any country, race or origin. The building served as a *waqf*. The hospital handled fever, eye diseases, surgery and dysentery, while musicians and story tellers provided entertainment for patients. During the Plague, the hospital continued to serve as a knowledge hub in fighting the pandemic. In Cairo, the Plague began in 1348 and continued for 150 years, with conditions worsening over fifty waves. The *madrasa* had polychrome marble floors and included a fountain and living units for scholars and students over three levels. The prayer hall emulated the design of a basilica with a higher central nave. The soffits and

voussoirs of the arches are decorated with the same stucco carving as the mausoleum of Qalawun. The tomb chamber resembles the Dome of the Rock in Jerusalem and the cosmatesque tradition of the marble mosaic decoration, cultivated in eleventh-century Italy, was perfected in Alexandria and Constantinople. The *madrasa* was decorated with wood, carved marble and stucco, and the niche indicating the direction of Mecca is the largest and most lavishly decorated Mamluk *mihrab*.

Al-Nasir Muhammad, the younger son of Sultan Qalawun, ruled from 1293 to 1294, 1299 to 1309, and again from 1310 until his death in 1341. This period is regarded as the height of Mamluk culture and Islamic civilisation. His mosque was built between 1318 and 1335. Located inside the citadel of Cairo, the mosque became the place of his family's Friday prayers. The two different minarets with fluted bulbous finials and glazed faience decoration are unique features, with one of the minarets possibly serving to call the troops to prayer. Al-Nasir Muhammad was the greatest builder of the Bahri dynasty,

17
Detail showing a *mashrabiya* window at the mosque
of the Emir Muhammad Bey Abu al-Dhahab.
Copyright: E. Khalifa

concentrating his main building activities at
the citadel with a remarkable exception: his
funerary *madrasa* located south of Qalawun's
mausoleum. Here, the façade includes a
Gothic portal, a war trophy seized by Sultan
Kitbugha – during whose reign, in 1296,
construction of the building had begun – and
brought from a church in Acre. The *madrasa*
shares some features, such as the closeness
of the minaret and the dome, with Qalawun's
mausoleum. It is in his father's mausoleum
that al-Nasir Muhammad chose to be buried.

The mosque of al-Maridani, the son-in-
law of Sultan al-Nasir Muhammad, is often
regarded as the finest monument of the four-
teenth century. It was built in 1339–40 outside
of Cairo, south of Bab Zuweila. Squeezed
into the urban landscape but of unmatched
design and craftsmanship, this mosque's
minaret stands next to the main portal, and
is the earliest minaret known to have an
octagonal shaft. One of the most remarka-
ble features is the wooden *mashrabiya* screen
which separates the sanctuary from the court-
yard. Usually found in domestic architecture
from the Middle Ages through the twenti-
eth century (figs. 3 and 17), this 'drinking
place-thing' is a feature that helps cool water
bottles and bowls of food through exposure
to air currents.

The mosque-*madrasa* of Sultan Hassan
was built between 1356 and 1363 when Cairo
was already in the grip of the Plague. It is
considered one of the most outstanding
historic monuments in Cairo today. Craftsmen
came from as far as Anatolia (modern Turkey),
and the fact that work continued during the
first three years 'without even a single day

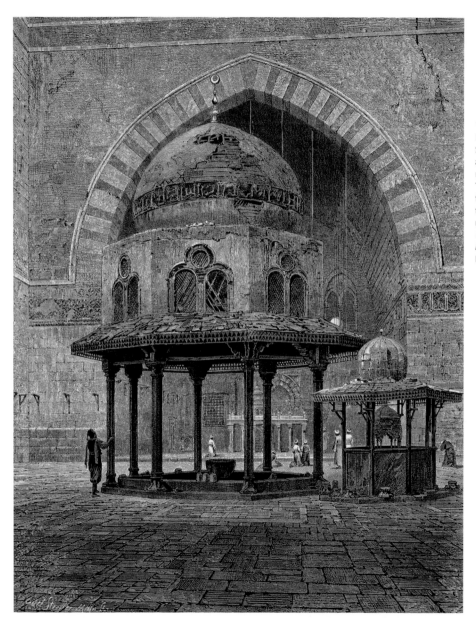

18
Inside the funerary complex of Sultan Hassan (1356–63), with an octagonal fountain and the main *iwan* in the background. The gazebo next to the fountain is no longer visible today and the floor has been restored. Artist: C. Werner (1871), in G. Ebers, *Ägypten in Wort und Bild* I (Stuttgart/Leipzig, 1878), 305

of idleness' is very likely due to the re-use of building material, especially from the Great Pyramid of Giza, completed by King Khufu in ca. 2566 BCE. Accessible to the public, the central courtyard is home to the now renovated ablutions fountain and the awe-inspiring main *iwan* in the direction of prayer (fig. 18).

LOOTED ANTIQUITY

Mamluk architecture in Cairo oscillates between adoption and demarcation. The most visible aspect of the Mamluks' success in striking a balance between these two poles is the inclusion of re-used building material, while simultaneously developing a unique formal idiom which established a fresh narrative of Islamic monumental architecture. This is hardly a coincidence and cannot sufficiently be explained as a way of cutting corners when working on costly building projects. Pharaonic building material was intentionally and purposefully used, similar to the inclusion of the Gothic portal from Acre in the funerary *madrasa* of al-Nasir Muhammad. At the

entrance to Baybars II's *khanqah* (1306–10), a building designed to accommodate Sufis committed to leading a life of prayer and poverty, a Pharaonic stone was used as a sill. In al-Nasir Muhammad's mosque, Pharaonic, Roman and Christian columns were used, while the mosque of al-Maridani recycled ancient Egyptian capitals. Especially with regards to the seemingly random inclusion of ancient Egyptian stone blocks, this phenomenon is not yet fully understood.

After Crusader cities and states had been overthrown, Mamluks returning to Cairo brought with them carefully selected and retrieved building materials, such as wood, iron and marble, during the twelfth and thirteenth centuries. While recycling Fatimid palaces may have contributed to the swift building progress of new Cairo, imported building materials, especially items that were clearly of Christian origin, contributed to the way the Mamluks wanted their success and their enrichment of Cairo to be understood. While the provenance of all these items remains unclear, almost every representative building included re-used material. Columns

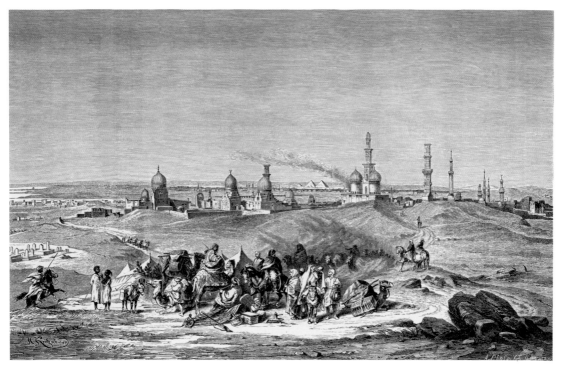

19
Cairo, view of the citadel with the pyramids in the background, looking southwest. This image illustrates the skyscape of the city, dominated by its minarets. Artist: H. Kretzschmer (1871), in G. Ebers, *Ägypten in Wort und Bild* I (Stuttgart/Leipzig, 1878), 317

were so readily available that Mamluk architects never saw the necessity of developing a distinct capital design. One example is a column in the mosque of al-Maridani which rests on a Christian plinth, which had itself been worked from an architrave in an Egyptian temple, likely the Temple of Ra in Heliopolis.

However, the inclusion of re-used material was no doubt partly driven by practical considerations. Oftentimes, the side of a block which displayed hieroglyphs was placed on the inside and thus became invisible. Nonetheless, the use of stones with hieroglyphic inscriptions has been explained through their supposed magical meaning, which may have

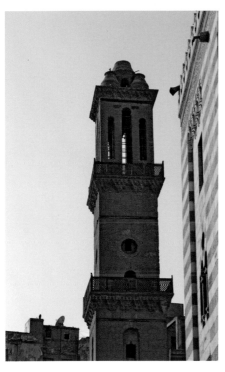

Minaret of the mosque (1774–5) of the Emir Muhammad Bey Abu al-Dhahab (Father of Gold), who declared the independence of Egypt from Ottoman rule and aimed at re-establishing the Mamluk Sultanate. It is part of the last large religious complexes built by Mamluk beys for the benefit of Islam. Copyright: E. Khalifa

be more nefarious explanations for re-usage. In 1354, the frequent re-use of building materials was highlighted by contemporary sources in the discussion of illegal looting, often overseen by officials who used their influence to raid buildings belonging to undesirable members of society.

Today, the minarets of the mosques of Qalawun and his son al-Nasir Muhammad still dominate Cairo. Houses were never built high in medieval Cairo, and minarets were always established at a higher level above the hustle and bustle of the streets (figs. 19 and 20). Deriving from Syrian church towers, minarets made their appearance during the Umayyad Caliphate between 661 and 750, but only in Mamluk Egypt did they create a novel approach by inhabiting the sky. Egyptian architect Hassan Fathy reiterated this when he stated: 'I am surrounded by five mosques, thanks be to God, with their domes and minarets and so I say I am living in a skyscape, not a landscape.'

been thought to protect buildings as well as those who entered them. It seems more plausible, though, to suggest that their inclusion helped ban the negative influence of polytheism (Sura 9:17). This seems to be confirmed by the Satrap Stela, kept in the Egyptian Museum in Cairo today, which had once been included – face down – in the foundations of a side chamber in the *khanqah* of Amir Shaikhu, built between 1355 and 1356. In addition, there may

THE ART OF SGRAFFITO

Martin Bommas and Bronwen Neil

Sgraffito is determined by a combination of various techniques applied to pottery and wall art. In pottery, the two most important characteristics make this ware instantly recognisable, as they are also design features: the scratching found on surfaces visible to the viewer, and the lead glaze. By applying two successive layers of contrasting glaze to an unfired ceramic body, and then in either case scratching so as to reveal parts of the underlying layer, sgraffito ware receives its characteristic surface treatment before firing.

Lead-glazed pottery originated in Egypt, but later came to be used by the Romans (fig. 21). Its surface renders it impervious to liquids, such as those contained in jugs or bowls, and thus its development allowed new

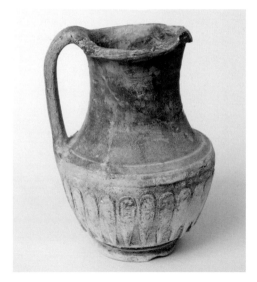

21
Roman jug, partially mould-shaped pottery with a patterned, green, lead-glazed body and one handle, restored. 1st–2nd century, 9.8 × 13.5 cm. MU4702

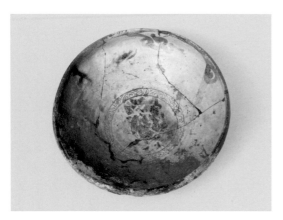

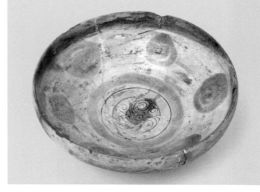

22
Large sgraffito bowl, restored, partly with sea growth. The sea growth suggests that the bowl was used in trading before it was probably discovered in a ship wreck. Eastern Mediterranean, 12th–13th century, 7.8 × 28 cm. MU4644

23
Sgraffito bowl with green underglaze, painted pottery with engraved decoration, restored. Levant, 12th–13th century, 8.6 × 24.8 cm. MU4645

cooking styles and recipes to emerge. Offering a wider range of possible colours than polychrome slip ware, the new technique did not, however, allow for vessels to be stacked up during the burning process, unless tripod-like stilts were used which usually left marks. As a result, production proved to be expensive. Also, lead is poisonous and had a negative impact on the life expectancies of potters. After the fall of the Roman empire, much of this ceramic technology was lost, but the use of lead in glaze continued in Byzantium and expanded into the Middle East, especially in the Levant (figs. 22 and 23).

Sgraffito evolved in the ninth to tenth century from Roman glazed wares with colour

splashes. Derived from the Italian verb *sgraf-fiare*, which means 'to scratch', *sgraffiato* – or, more commonly, *sgraffito* – refers to the technique used to design the incised decorations. The origin of the word is the Greek *gráphein*, 'to write'.

Sgraffito vessels were wheel-thrown. After the bodies of the vessels were formed, they were left to dry and, once leather-hard, rough-coated with a white slip. As the focus was on the decoration and not on the sides of the bowls, the white slip was often accidentally and irreversibly applied to the outsides of vessels as well. After drying, the designs were scratched through the slip to expose the reddish colour of the clay before firing took place in two stages. First, the vessels with the white surface and scratching were fired at a temperature around 1000–1050 °C. After cooling, the colours were then splashed onto the surface of the vessels and distributed along the lines of the scratched patterns but also added to non-scratched parts. Bowls usually show a tondo inside with carved vegetation decoration. Some are also painted with tendrils or line decoration. The second firing would occur at around 700–750 °C.

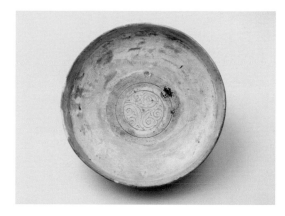

24
Small sgraffito bowl with green underglaze, painted and engraved decoration with delicate spiral motif in fine-sgraffito line, ring foot, restored. Byzantium, 12th–13th century, 4.5 × 18.5 cm. MU4643

The Byzantines pioneered the widespread use of sgraffito to decorate their tableware (fig. 24; see also fig. 31). This method of decoration was taken up in Islamic societies throughout the Islamicate East. A similar technique was used in Byzantine glassware and painting, on panels and in manuscripts, where the ground layer was sometimes gold leaf.

umanimis ſ̄ īn eum · Et eicientes eu
extra ciuitatē lapidabant · Et teſt
depoſuerūt ueſtimēta ſua ſecus pede
adoleſcentis qui uocabatur ſaulus ·
lapidabant ſtephanū inuocantē et
cētem · dn̄e ih̄u ſuſcipe ſp̄m meū ·
aūt gēibz clamauit uoce magna · d
ne ſtatuas illis hoc pecctū · Et cum
dixiſſ; obdormiuit indn̄o · Saulus
aūt conſentiens nẽci eius ·

Acta est aūt in illa die pſecutio mag
ī ecclā que erat ieroſolimis · z oīs
ſp̄si ſūt p̄ regioēs iudee z ſamarie
ter apl̄os · Curauerūt aūt ſtephan̄
ri timorati · et fecerūt planctū ma
ſup eum · Saulus aūt deuaſtabat
p domos intrās z trahens uiros
mulieres tradebat in cuſtodiā · Igit
diſpſi erant ptranſibant euangeliʒ
uibum dei · philippus aūt deſcendē
ciuitatē ſamarie pdicabat ill̄ xp̄m ·
tendebant aūt turbe his qui appli
dicebant unanimiſ audientes · z

THE BOOK OF HOURS

Martin Bommas and Louise D'Arcens

Before printed books, manuscripts (literally 'written by hand') were the dominant medium for recording and disseminating knowledge in medieval Europe. The best-known form, especially from the later Middle Ages, is the codex, or bound book, which largely came to replace the continuous scroll. Many bound manuscripts contained several texts: sometimes their content was religious (fig. 25), sometimes secular, and sometimes both. The leaves were most commonly made from vellum – scraped, stretched and treated calf skin – which offered a robust and durable writing surface. Produced in workshops and monastic scriptoria, they ranged in quality from illuminated presentation manuscripts through to unadorned workaday volumes.

The most common type of surviving medieval illuminated manuscript of Christian origin is the Book of Hours (fig. 26). Being popular devotional books, their manuscripts contain similar collections of texts, with an amount of personal variation, but are unique in the way they are illuminated. Illumination can range from minimal, often restricted to decorated capital letters at the beginning of psalms, to manuscripts with full-page illustrations. Mostly, but not exclusively, written in Latin, the typical Book of Hours is an abbreviated version of the breviary, which was recited in monasteries. Laypeople's use of them added a monastic dimension to their devotional lives. Reading a number of prayers and psalms was the most common way to recite the eight canonical hours of the day.

While the breviary developed in the twelfth century, the abbreviated version used by people who led secular lives became widespread by

25
Leaf from a Latin Vulgate bible, written in brown
ink with space between columns decorated in
red and blue ink. The text is 1 Samuel: 22–24.
19.2 × 29 cm. PAP/INV/639

the fourteenth century. During the fifteenth century small versions without illuminations became affordable and were often given to new brides by their husbands. When a patron commissioned a Book of Hours, he or she could request selections of favourite prayers and illustrations. In the later Middle Ages, it was not uncommon to purchase a pre-produced, generic Book of Hours from a manuscript workshop.

26

Leaf from the Book of Hours. Animal vellum, dark brown ink in gothic script, extenders in gold on blue and red grounds with white tracery. The letter 'B' starts Psalm 145: 5–10 ('beatus cuius…'). These volumes were used for private devotion by late medieval laypeople, including women of the aristocratic and mercantile classes. This leaf is from the 'Office of the Dead', praying for the deceased. Paris, 15th century, 12 × 17.5 cm. PAP/INV/641

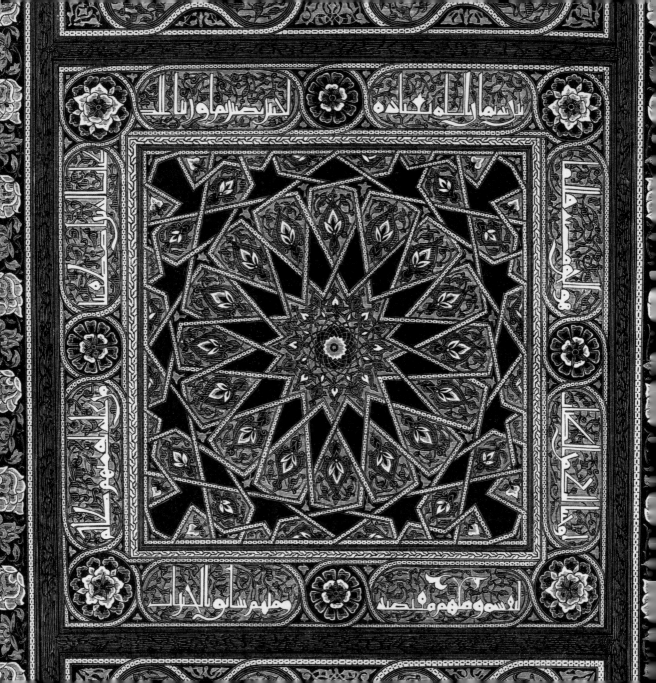

'WE HAVE SENT DOWN THE QUR'AN OURSELF, AND WE OURSELF WILL GUARD IT'

(Sura 15: Al Hijr, Aya 9)

Mohamad Ali

Calligraphy is the most enduring art form to have emerged in Islamic civilisations. The dominant quality and charisma of the calligraphy is attributed to the incontestable status accorded to the canonical text of the religion, the Qur'an – the fundamental source of the creed, rituals, ethics and law of the Islamic religion.

The styles of calligraphy used in Islamic art have varied and evolved throughout the ages. The forms and styles of calligraphy applied in various parts of the Islamic world were often geographically and culturally influenced. These differences are found to varying degrees in the format (the layout and presentation of the Arabic script), ductus (the horizontal movement of the letters), ligatures (the apt process of banding letters when forming a word) and vocalisation markers (found above and below the Arabic letters). These variants spurred a malleable and ornamental mode of script that enabled Islamic artisans (calligraphers, miniaturists, potters and ceramicists, glass blowers, metal workers, textile and carpet weavers,

carpenters, stone masons and architects) to adopt the style(s) that best suited their medium and the purpose of their craft. The main purpose of Qur'anic calligraphy, though, was to provision Divine direction to the faithful during the ritual of the recitation of the Word of God whilst in prayer. Concurrently, the key decorative elements of the written Qur'an aid the faithful and enable the non-religious observer to contextualise the meanings embedded in Islam's holiest book.

According to *hadith* ('Sahih Bukhari', vol. 1, book 1, Hadith no. 3), when the Prophet was nearly forty years of age (around the year 610), he spent many a time alone in the Hira cave, in Al-Nur mountain some 3 km from Mecca, speculating over the aspects of creation. It is believed that during these meditative years the Qur'an was revealed to Muhammad in several parts by the angel Gabriel.

During the Prophet's life, the Qur'an was never transcribed in its entirety as one collated book. Instead, it was memorised by as few as six of his companions. Only large passages of the Qur'an were written down in Mecca, mostly carved into stone on walls of mosques, and incised onto animal bone and parchment, as paper was not yet common in Arabia.

Following the Prophet's death, the succeeding Caliph, Abu Bakr, commissioned one of the Prophet's personal secretaries in Medina, Zayd bin Thabit (also one of the few to have memorised the entire Qur'an), to collect and scribe the very first Qur'an on sheets of parchment. In due course complete, tangible copies of the Holy Book were produced. This alleviated the very burdensome task of memorising the entire script. Additionally, these copies guaranteed a more accessible, uniform and accurate text for followers of Islam, particularly as the religion expanded across the region. This is what Al-Hijr, Verse 9 (see chapter title) refers to.

However, formatting still presented a problem: each chapter (Sura) and verse (Aya) needed to be sequenced; and the early copies of the Qur'an lacked important vocalisation markings that hindered the precision of reading, thus causing great concern that the Word of God was open to ambiguous pronunciation and ultimately corrupt interpretation. The Birmingham Qur'an, in the Mingana

Collection at the University of Birmingham, which dates back to the first century of Islam and the rule of the first three Caliphs, is one of the oldest known Qur'ans in existence and exemplifies some of these anomalies. Most of the text in the Birmingham Qur'an is without vocalisation markings. Chapter headings are lacking, too. Verse dividers are marked by an inconsistent count of dots and, in some instances, verses flow from one to the next without any divisional indicators. These problems began to be addressed by the third Caliph, Uthman ibn Affan (576–656), around the mid-seventh century. Uthman ordered the recollection and burning of all publicly owned copies of the Qur'an. He then ordered the re-scribing of the text, in a sequenced order, inclusive of important vocalisation and vowel indicators to ensure accuracy of the Qur'an in both written and oral forms. These advances to the structure of the text became known as Uthman's Codex. As Islam spread, Uthman's Codex underwent further development. This included: the introduction of Sura Headings being explicitly scribed before the *Bismillah*, the first verse of each chapter where God's name is recited as the Most Merciful and Compassionate (late eighth century onwards); and Aya Dividers coming into existence (tenth century onwards) and being numbered (eighteenth century onwards). The structural developments ensured that content could be distinguishable and easily referenced by worshippers and leading scholars of the faith.

In these strikingly large Qur'an leaves (figs. 27 and 28), the script is fully vocalised, verses are clearly divided and, for ease of reference, verse counters appear in the margins. Additionally, this Qur'an conveys some of the most central artistic features attributed to Mamluk calligraphers. The Mamluks made their appearance as military slaves recruited by the Ayyūbid Sultan of Egypt, al-Malik al-Ṣaliḥ Najm al-Dīn Ayyūb (1205–1249). The lasting legacy of the Mamluk Sultanate (1250–1517), in addition to strategic warfare, is embedded in the promotion of learned institutions, an unprecedented scale of academic endeavour and stimulating visual arts, as well as the establishment of charitable primary schools for orphan boys who socially ascended to become 'men of the pen'. In this example, the sweeping strokes

27

Page of a Qur'an, calligraphic writing on pink paper (recto and verso) illuminated with gold, containing Sura 16 Al-Nahal (The Bee). 14th century, 33 × 45 cm. Al-Khatt Al-Jameel Private Collection, Sydney (MAM Q-MUH -09A)

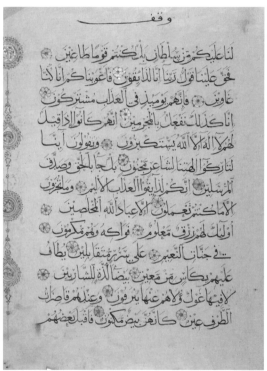

28
Page of a Qur'an, calligraphic writing on pink paper
(recto and verso) illuminated with gold, containing
Sura 37 Al-Saafat (The Ranks). 14th century, 33 ×
45 cm. Al-Khatt Al-Jameel Private Collection, Sydney
(MAM Q-MUH -11B)

of the script were designed to mimic the sharp tips of the battlefield-warrior's sword, thus symbolising the valour, gallantry, fortitude and superiority of the Mamluks, creating a quality and style of calligraphy unmatched by any other across medieval Arabia.

The astonishing level of ornamentation – specifically, the array of celestial marginal medallions – demonstrated the focus on spirituality. The medallions encompass the alternating words 'khams' and 'ashr' in a gold-leafed floriated-Kufic script to mark the fifth and tenth verse counts respectively; these are then elaborately illuminated in red and gold swirling arabesque patterns. More specifically, the fifth verse markers are embellished by a gold-grounded teardrop cartouche bordered by overlapping saffron lappets. The rise in the shape's tip symbolised the peak of one's spiritual journey. The tenth verse markers appear as gold sun-shaped discs bordered by green lappets. Here the sun motif represents the Power and the Mercy of Allah. This is reflective of the message within the Qur'an itself: 'It is He Who created the night and the day, and the sun and the moon; all (the celestial bodies) swim along, each in its rounded course' (21:33). Moreover, the verses in this Qur'an are bookended by polychrome floral formations, all proportionally arranged within an invisible rectangular border to complement the shape of the polished pink paper medium. Collectively, these artistic attributes convey a sophisticated divine motif emblematic of the 'miracles' that the faith revolved around: the Qur'an and the Paradise it promised. Both are considered by Muslims to be too perfect to be the work of mankind and therefore must be the product of Allah. The Qur'an reveals Allah's message to the faithful, explaining that the grandeur of Heaven is the greatest reward that awaits those who follow His instruction. The motifs identified above supplement this belief. The vegetal and floral arabesques are inspired by the gardens of Jannah (Heaven); celestially influenced geometric shapes and gold leafing are symbolic of the supremacy and faultlessness of the Islamic faith.

The extraordinary size and exemplary ornamentation of the Qur'an shown here could indicate that it was intended not as a practical object, but rather as a public demonstration

of power, wealth and piety. However, at the top left of each leaf of this Qur'an is the Arabic word *waqf*, which then leads one to conclude that this manuscript was destined for a *khanqah*, or a grand mosque. This Qur'an may also have been intended as a gift to an Islamic *madrasa*. Regardless, its cropped edge reveals that it was probably a commonly used Qur'an, which worshippers in the fourteenth century used daily. Legend has it that a local imam of a well-established mosque in medieval Cairo was in the process of spring-cleaning and needed some extra pairs of hands. He sauntered onto the street to round up a group of young boys whom he could put to work for a scanty copper dirham. The task they were assigned was one that many modern day preservationists would be aghast at. The boys were given a guillotine knife to do away with the fraying edges of a large stack of manuscripts that sat earnestly on the shelves for worshippers to use. 'Make sure the pages are crisp', he would have instructed them. And that was it! Perhaps this explains the current state of Qur'anic pages today.

Additionally, it has been suggested that the banning of iconography and idolatry in Islam helped to impel the rich adornments of the calligraphic form, redirecting artistic emphasis onto the Qur'an. The scope of calligraphic adornment varied, due to a variety of factors that would have influenced what an artisan was trying to achieve. Such factors included the intricacies of the adornment, financial backing, provincial commissioning, size of the finished work, materials used, expenditure of time, and the nature of assistance lent to the master artisan by their apprentice(s).

Arabic calligraphy flourished in the Islamic world (figs. 29 and 30), becoming the dominant form of embellishment on a vast range of objects both sacred and secular. It developed into a script that defined geometric and architectural rules of layout, spacing and structure. The plasticity of the Arabic letters was such that they could be executed and moulded into an array of motifs and symbols that epitomised the culture of the artisan. Whether scribed in an abstract, mystical, vegetal, floriated or topographical motif, the script always gave the impression that it was of an incontestable status.

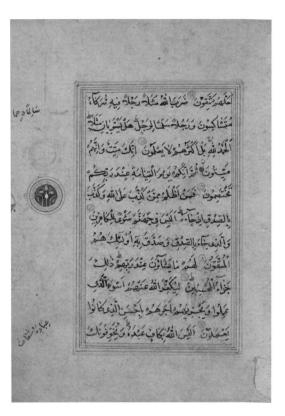

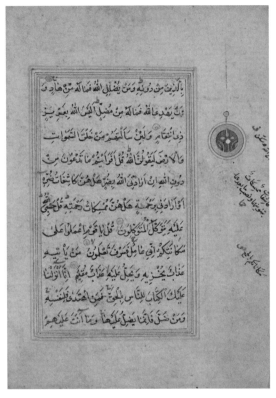

29
Page of a Qur'an, calligraphic writing and painting
on paper (frame and dots between verses) and
medallion ornament, characteristic of the Mamluk era,
containing verses from Sura 39 Al-Zumar (The
Throngs). Levant, Mamluk era, before the year 1517,
8.4 × 11.9 cm. Private Collection, Sydney

30
Frontispiece from a Qur'an dating
to the time of al-Ashraf Sha'ban
II (r. 1363–77). Illuminated
monumental Qur'ans were
especially produced during
the middle and later Mamluk
periods, and were often
commissioned by Mamluk sultans
as endowments for institutions.
Artist: R. Huthsteiner, in G. Ebers,
Ägypten in Wort und Bild II
(Stuttgart/Leipzig, 1879), ix

THE MIDDLE AGES IN SYDNEY CULTURAL INSTITUTIONS: WESTERN AND EASTERN

Louise D'Arcens

When it comes to holdings of medieval material culture in Australian institutions and private collections, what we encounter is better described as 'South meets West' than 'East meets West'. Australia's colonial past shaped tastes and approaches to cultural heritage in ways that guaranteed that the 'presence' of the Middle Ages reflected a strong orientation toward the medieval West. Just as the great university- and cathedral-building projects of colonial Australia favoured a Gothic Revival style to mark the colonies' link to a deep medieval heritage, so too collectors of medieval treasures, especially of medieval manuscripts, sought out examples of the Anglo-European, Christian tradition to which they felt connected. This orientation was reflected in school and university curricula, which centred on the medieval West; even the Crusades and the Byzantine Empire were taught from a Western perspective.

Increasingly, though, scholarly interest has turned toward exploring the years between approximately 500 and 1500 – that is, the time that Western nomenclature calls 'the Middle Ages' – as an epoch of

interconnectedness: of East-West exchanges, migrations and interfaith encounters. Within this scholarly development, the Middle Ages are now increasingly coming to be understood under the auspices of a *longue durée* reconceptualisation of 'the global'. To this end it is worthwhile understanding what artefacts from the medieval East are held in the collections of Australia's public cultural institutions. This is an ongoing project that will need to encompass private as well as public collections, but the *East Meets West* exhibition at the Macquarie University History Museum provides an opportunity for an interim report on this work, focusing on Sydney's major public collections only, in order to contextualise the medieval items displayed by the Museum.

Sydney's best-known collections containing medieval material culture include those gathered by Sir Charles Nicholson, Sir William Dixson, Nelson Moore Richardson and the archaeologist Professor James Stewart. Dating from the nineteenth and early twentieth centuries, their colonial affiliations are apparent, either in their emphasis or in their rationale for donation: for instance, the British Richardson's gifting in 1926 of manuscripts to the State Library of New South Wales was an expression of gratitude for the Australian war effort in World War I. It is also true, however, that these collections reflect the travels and personal proclivities of the collectors, rather than any official public programme of collection. The emphasis on the European Middle Ages found in these early collections continues in recent important collections, principally the Kerry Stokes Foundation's holdings, which features acquisitions such as the richly illuminated Rothschild Hours, a Flemish manuscript dated to 1500–20.

The *East Meets West* exhibition displays the five Crusader-era (twelfth/thirteenth century) sgraffito bowls held at Macquarie University History Museum (see figs. 15, 22–24 and 31). Sgraffito was a decorative style found on later medieval ceramic tableware, in which a design has been carved through a pale clay-and-water slip, exposing the colour of the earthenware beneath (see also p. 43). Another distinctive feature of much sgraffito is a green and brown glaze, boldly applied in circles, strokes and

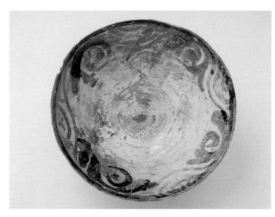

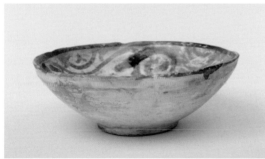

31
Medium sgraffito bowl with vibrant green under-glaze volutes and delicate sgraffito line medallion in centre, restored. Byzantium, 12th–13th century, 7.3 × 19.8 cm. MU4642

swirls. These features can be seen in the bowls on display at Macquarie University History Museum. Bowl MU4642, for instance (fig. 31), has a decorative tondo (circular pattern) inscribed into the centre of its well, decorative swirls, and a dark rim that bears the influence of Cypriot style. This widespread technique originated in Persia in the tenth/eleventh century, but spread across the eastern Byzantine Empire, the Islamicate East, the Levant and the Eastern Mediterranean, and production was prolific during the Crusader period. The geographical provenance of the Macquarie bowls has not been determined exactly; and indeed the provenance of sgraffito objects can be complex to determine, partly because of the cross currents of influence between local styles (for instance, Cypriot techniques had a noted impact on Egyptian Mamluk style), and partly because of the intensive trading of these objects. More recently, this has been further complicated by the fact that the modern market includes many looted objects of unclear origins.

Other Sydney collections also include medieval sgraffito bowls. The Powerhouse /

Museum of Applied Arts and Sciences (MAAS) holds eighty-two bowls from Cyprus dating between 1200 and 1400, when Cyprus was under the rule of the Crusader Lusignan dynasty. These objects come from the collection of James Stewart, founder of the Department of Archaeology at the University of Sydney, donated by Stewart in 1948. They are believed to be grave goods – tableware that had been placed in graves – which had in turn been looted and sold on. Items from Stewart's collection of Cypriot objects were also donated to the Nicholson Museum, and are now housed at the Chau Chak Wing Museum of the University of Sydney, which also includes Crusade-era sgraffito wares from more recent excavations in Cyprus.

Medieval ceramics from the Islamicate East also form part of the collection at the Art Gallery of New South Wales and the Powerhouse / Museum of Applied Arts and Sciences. This includes Turkish and Persian vessels (some of which had earlier been mistaken for Chinese because of the mutual stylistic influences between Chinese and Persian blue-and-white ceramics). The Powerhouse boasts a splendid Mamluk earthenware vase with decorative glazing, dated 1250–1350, and a collection of thirty-six decorative tiles from across the Islamicate world but Turkey and Syria in particular, dated between 1200 and 1800 CE. Unsurprisingly, the non-Western sculptural items from the period 500–1500 CE held in the Art Gallery of New South Wales, some of which are on display in its permanent Asian Galleries, are predominantly stone and bronze religious statues from the Buddhist and Hindu cultures of mainland Southeast Asia and India. This reflects Australia's longstanding relations in the region: the first large donation was a collection of ceramics and bronzes gifted by the Government of Japan in 1879.

Numismatics, the study of currencies, has for some time been a strong area of research at Macquarie University. The collection that has resulted from this, held by the Australian Centre for Ancient Numismatic Studies (ACANS), has concentrated on currencies from pre-medieval societies. The two early Mamluk-era coins displayed in the *East Meets West* exhibition are quite

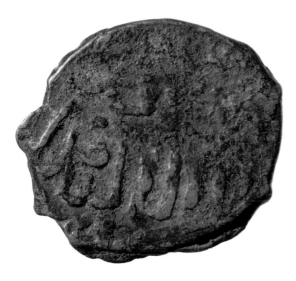

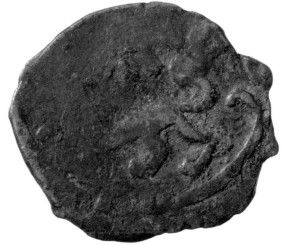

32
Mamluk coinage, al-Ashraf Sha'ban II
(r. 1363–77), 2.66 grams; obverse, field with two
lines of legend within circular border; reverse,
lion passant to left, within dotted circular border.
Bahri Dynasty, 1363–77, diam. 2 cm. U447

different (see figs. 7 and 32). These coins are
from the fourteenth-century Bahri dynasty,
as is evident from the lion passant (walking
lion) image on coin U447, dated to 1363–77
(fig. 32). Coins from the medieval East can
also be found in other collections in Sydney.
The Powerhouse / Museum of Applied Arts
and Sciences has a collection of over 100
silver, copper alloy and (more rarely) gold

coins from across the medieval Byzantine
and Islamicate worlds, including Central
Asia, North Africa, the Middle East, and
the Crusader states of the Mediterranean,
dating back as early as 661, only decades into
the emergence and spread of Islam. This
museum also holds the remarkable 'Kilwa
coins', a collection of five copper coins from
the East African sultanate of Kilwa Kisiwani
which were found in 1944 on Yolngu country,
in the Wessel Island chain off the Arnhem
Land coast. Dated from ca. 900 to 1300 CE,
they bear the names of identifiable rulers,
such as Sulaiman ibn al-Hasan, the sultan

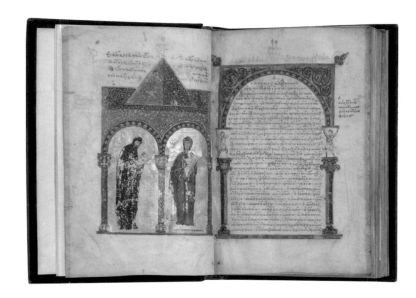

33
The Gospel Book of Theophanes (Tetraevangelion), brown and gold inks, tempera and gold leaf on parchment, modern crimson velvet binding. Constantinople, ca. 1125–50, 24.2 × 27.4 cm. National Gallery of Victoria, Melbourne, acc. no. 710-5

between 1310 and 1333. While researchers are still trying to understand how the coins came to be on Marchinbar Island, at the very least this hoard reflects the dynamism of trade across the Indian Ocean into the seas north of Australia.

Medieval manuscript collections in Australia are mostly held in public institutions, with particular concentrations at the State Library of New South Wales, State Library Victoria and the University of Sydney. Medievalists Margaret Manion, Vera Vines, Keith Sinclair, and most recently Anne

Dunlop, have documented Australian holdings. Their work has given particular attention to illuminated manuscripts. Most of Australia's manuscript collections, which are modest by comparison with the enormous collections compiled by US benefactors such as Henry and William T. Walters, have focused on the acquisition of European treasures, with most hailing from Italy, France and the Low Countries. The leaves from Latin Vulgate bibles and late medieval Books of Hours held by the Macquarie University History Museum and exhibited in the *East Meets West* exhibition

(see figs. 25 and 26) reflect the focus on Christian devotional texts that is also found in the larger Australian collections. Some of the better-known texts of this kind in Sydney include the illuminated Rimini Antiphonal, a Northern Italian choir book dated to 1328, held at the State Library of New South Wales. One well-known exception among these books of Western Christianity, discussed in detail by Manion and Vines, is the impressive early twelfth-century Byzantine Gospel Book of Theophanes, held by the National Gallery of Victoria (fig. 33). The Qur'an manuscript leaves featured in the *East Meets West* exhibition, on private loan (see figs. 27–29), are two of only a few medieval Arabic manuscripts held in Sydney; others include pages from a fourteenth-century Egyptian Qur'an held by the Art Gallery of New South Wales (fig. 34), and, at the University of Sydney, a number of undated Qur'an manuscripts and a fourteenth-century grammatical commentary.

More remains to be known and said about the material culture of the Eastern Middle Ages in Sydney, as our modern understanding of this complex period both broadens and deepens.

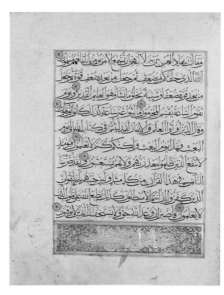

34

Page of a Qur'an, calligraphic writing (tuluth script), opaque watercolour and gold, containing verses from Sura 43 Az-Zukhruf (Ornaments). Egypt, mid-14th century, 41 × 32 cm. Art Gallery of New South Wales, acc. No. 236.2003

TIMELINE

Georgia Barker

323 BCE to 31 BCE Hellenistic Period

323 BCE	–	Death of Alexander the Great
31 BCE	–	Battle of Actium

27 BCE to 393 CE Roman Empire

312 CE	–	Battle of the Milvian Bridge in which Constantine I defeats Maxentius and receives a divine vision and command
313	–	Emperor Constantine I grants freedom of religion, ending persecution of Christians
330	–	Founding of Constantinople as the new capital of the Roman Empire
380	–	Emperor Theodosius I declares Christianity the official religion of the Roman Empire

330 CE to 1453 CE Byzantium

395	–	Roman Empire divided into East and West
476	–	Western Empire falls
ca. 570	–	Birth of Muhammad
ca. 632	–	Death of Muhammad

969 to 1171 Fatimid Caliphate

ca. 1000	–	Arabic is introduced as a language for the public performance of church ceremony in the Coptic Church
1066	–	The Battle of Hastings and the Norman conquest of England
1095	–	Pope Urban II proclaims the First Crusade
1096 to 1099	–	First Crusade in the Holy Land
1099	–	Capture of Jerusalem by First Crusaders
1120	–	Foundation of the Knights Templar in Jerusalem
1145	–	Pope Eugenius III proclaims Second Crusade
1147 to 1149	–	Second Crusade in Iberia, Near East and Egypt

1171 to 1250 Ayyūbid Sultanate

1187	–	Saladin conquers Jerusalem
	–	Pope Gregory VIII proclaims Third Crusade
1189 to 1192	–	Third Crusade in Anatolia and Levant
1198	–	Pope Innocent III proclaims Fourth Crusade
1202 to 1204	–	Fourth Crusade in the Balkans and Anatolia
	–	Beginning of the decline of the Byzantine Empire

1204	–	Sack of Constantinople by Crusaders, marking the end of the Fourth Crusade
1212	–	Children's Crusade, an unsanctioned popular movement in which thousands of young European people unsuccessfully set out to recover Jerusalem
1217 to 1221	–	Fifth Crusade, initiated by Pope Innocent III
1228 to 1229	–	Sixth Crusade, led by Holy Roman Emperor Frederick II
	–	Crusaders retake Jerusalem
1234 to 1241	–	Baron's Crusade, proclaimed by Pope Gregory IX
1248 to 1254	–	Seventh Crusade, led by King Louis IX of France

1250 to 1517 Mamluk Sultanate

1250	–	Crusaders defeated in Mansourah, Egypt, by Mamluks
1258	–	Al-Mustansir installed as the first Caliph in Cairo, legitimating the new Mamluk rule over Egypt
1263 to 1363	–	Formative years of Mamluk architecture in Cairo
1270	–	Eighth Crusade, also led by King Louis IX of France
1271 to 1272	–	Ninth Crusade, led by Lord Edward, Duke of Gascony (future King Edward I of England)
1291	–	Acre (one of the final remaining Crusader cities) is captured by the Mamluks
1312	–	Suppression of the Knights Templar by Pope Clement V
1337	–	Start of the Hundred Years' War between England and France
1346 to 1353	–	Black Death (bubonic plague)
1410	–	First Battle of Tannenberg (Grünwald), in which the Poles and Lithuanians defeat the crusading religious order, the Teutonic Knights, shifting the balance of power in Central and Eastern Europe
1444	–	Invention of the printing press
1453	–	Ottomans capture Constantinople; fall of the Byzantine Empire
	–	End of the Hundred Years' War
ca. 1455	–	Printing of the Gutenberg Bible

GLOSSARY

Aristotle — philosopher and polymath during the era of Classical Greece (384–322 BCE)

breviary — liturgical book used in Christianity to pray during the seven fixed prayer times of canonical hours

Caliphate — Islamic state under the leadership of a steward (caliph), considered a politico-religious successor to the Prophet Muhammad

Emir — title of a military leader or sovereign principal, mostly used in Arab countries

exarchate — any territorial jurisdiction (secular or ecclesiastical) whose ruler is described as a military, political or ecclesiastical leader (exarch)

Franks — term used to denote Western Europeans (together with 'Latins') by peoples of the Middle East, distinguishing them from 'Greeks', the name for Byzantine Christians

hadith — term for what the majority of Muslims believe to be a record of the words, actions and silent approval of the Prophet Muhammad

iwan — of Persian origin, a rectangular hall or space, mostly vaulted, walled on three sides

Khan — historic title of Central Asia, referring to a military leader or ruler

khanqah — residential institution endowed for Sufis (Muslim ascetics)

madrasa — educational institution, or school; literally, 'place of study'

mashrabiya — wooden lattice window found in domestic and religious architecture

mihrab — niche indicating the direction to Mecca and prayer

minaret — tower from which the call to prayer is given five times a day; literally, 'beacon'

prester — or presbyter, from *presbyteros* (Greek), a bishop in an overseeing role

qibla — the direction toward the Kaaba inside the Sacred Mosque in Mecca, indicating the direction of prayer

scriptorium — a room devoted to writing in medieval European monasteries; literally, 'place of writing'

tetrarchy — system of government of the ancient Roman Empire, instituted by Roman Emperor Diocletian in 293, dividing the empire between two senior emperors

tondo — circular work of art, either a painting/drawing or a sculpture; literally, 'round' (Italian: *rotondo*)

waqf — endowment or assignment of revenue in perpetuity to religious, educational or charitable purposes, which cannot be 'alienated' (i.e., taken back, sold or given away); literally, 'stop' or 'contain'

wikala — bonded warehouse for storage of goods, with upper floors for rent

SELECT BIBLIOGRAPHY

The Crusader Period and Medieval Understandings of the East

K. Brewer, *Prester John: The Legend and its Sources*, Crusade Texts in Translation 27 (Farnham, 2015).

P. Jackson, *The Mongols and the West, 1221–1410* (Harlow, 2005).

N. Morton, *Encountering Islam on the First Crusade* (Cambridge, 2016).

K. Phillips, *Before Orientalism: Asian Peoples and Cultures in European Travel Writing, 1245–1510* (Philadelphia, 2014).

The Byzantine Empire

M. Acheimastou-Potamianou, *Byzantine and Post-Byzantine Art*, exh. cat., Ministry of Culture, Byzantine and Christian Museum (Athens, 1986).

S. Hornblower, A. Spawforth and E. Eidinow (eds.), *The Oxford Classical Dictionary*, 4th ed., s.v. 'Byzantium' (Oxford, 2012), 256.

B. Neil, *Dreams and Divination from Byzantium to Baghdad, 400–1000 CE* (Oxford, 2021).

K. Onasch and A. Schnieper, *Ikonen. Faszination und Wirklichkeit* (Freiburg/Basel/Vienna, 1995), 31–101.

H. A. Pohlsander, 'Constantine I', in: De Imperatoribus Romanis. An Online Encyclopedia of Roman Emperors, https://www.roman-emperors.org/conniei.htm (last accessed 6 April 2021).

W. D. Ray, *Tasting Heaven on Earth: Worship in Sixth-Century Constantinople* (Grand Rapids/Cambridge, 2012).

P. Schaff (ed.), 'Canons of the Council of Constantinople (381)', in: *The Seven Ecumenical Councils. Nicene and Post-Nicene Fathers* series 2, vol. 14 (Edinburgh, 1899), 178.

The Invention of Skyscape

W. B. Bartlett, *Islam's War Against the Crusaders* (Stroud, 2008), esp. 227–9.

D. Behrens-Abouseif, *Cairo of the Mamluks: A History of the Architecture and its Culture* (Cairo, 2007).

U. Haarmann, 'Die Sphinx. Synkretistische Volksreligiosität im spätmittelalterlichen islamischen Ägypten', in: *Saeculum* XXIX.4, 1978, 367–84, esp. 377.

R. Irwin, 'Islam and the Crusades, 1096–1699', in: J. Riley-Smith (ed.), *The Oxford Illustrated History of the Crusades* (Oxford/New York, 1995), 245–6.

A. Kamal, *Stèles ptolémaïques et romaines. Catalogue général des antiquités égyptiens du Musée du Caire I* (Cairo, 1905), 168–71 (CG 22182).

V. Meinecke-Berg, 'Spolien in der mittelalterlichen Architektur von Kairo', in: W. Kaiser (ed.), *Ägypten, Dauer und Wandel* (Mainz a. Rhein, 1985), 131–42.

E. Rogan, *The Arabs: A History* (London, 2012), esp. 18.

C. Williams, *Islamic Monuments in Cairo: The Practical Guide* (Cairo, 1999).

The Art of Sgraffito

E. Basso, 'Unravelling the Hidden Production History of *Sgraffito* Ware from Nishapur', Metropolitan Museum, New York, 2015. See https://www.metmuseum.org/blogs/ruminations/2015/production-history-of-sgraffito-ware-from-nishapur (last accessed 6 April 2021).

E. Katsara, entries 7, 13, 19, 47, 68 and 69, in: D. Papanikola-Bakirtzi (ed.), *Byzantine Glazed Ceramics: The Art of Sgraffito*, exh. cat., Museum of Byzantine Culture, Thessaloniki (Athens, 1999–2000).

For 3D scans of vessels, see https://foa.mq.pedestal3d.com/grid (last accessed 6 April 2021).

The Book of Hours

W. Hirst, 'The Fine Art of Illumination', Heritage Collection, Nelson Meers Foundation, State Library of New South Wales (Sydney, 2003).

'We have sent down the Qur'an Ourself, and We Ourself will guard it'

R. Azlan, *No god but God: The Origins and Evolution of Islam* (New York, 2005).

M. A. S. Abdel Haleem, *The Qur'an: A New Translation* (Oxford, 2015).

M. A. Hussein, *Vom Papyrus zum Codex. Der Beitrag Ägyptens zur Buchkultur* (Erfurt, 1972).

M. Lings and Y. H. Safadi, *The Qur'an: A British Library Exhibition* (London, 1976).

L. Reinfandt, 'Zum Schulunterricht im frühislamischen Ägypten', in: B. Palme (ed.), *Hieroglyphen und Alphabete. 2500 Jahre Unterricht im alten Ägypten* (Vienna, 2016), 47–58.

Y. H. Safadi, *Islamic Calligraphy* (London, 1978).

The Middle Ages in Sydney Cultural Institutions

B. Andrews, *Australian Gothic: The Gothic Revival in Australian Architecture from the 1840s to the 1950s* (Melbourne, 2001).

M. Manion and Vera F. Vines, *Medieval and Renaissance Illuminated Manuscripts in Australian Collections*, with foreword by K. V. Sinclair (Melbourne/London/New York, 1984).

S. Trigg (ed.), *Medievalism and the Gothic in Australian Culture* (Turnhout, 2006).

B. J. Walker, T. Insoll and C. Fenwick (eds.), *The Oxford Handbook of Islamic Archaeology* (New York, 2020).

ABOUT THE AUTHORS

Mohamad Ali is the Founder, Director and Curator of the Al-Khatt Al-Jameel Private Collection of Qur'an Manuscripts based in Sydney. He has been collecting and studying Qur'an manuscripts for 20 years. Additionally, he is a Senior English Teacher and Head Teacher of Welfare with the NSW Department of Education.

Dr Georgia Barker is an Honorary Postdoctoral Associate in the Department of History and Archaeology at Macquarie University, specialising in ancient Egyptian funerary art of the Old and Middle Kingdom periods. She has worked at the Metropolitan Museum of Art in New York and the Macquarie University History Museum.

Martin Bommas is Professor and Director of the Macquarie University History Museum. He has taught Egyptology at universities in Germany, Switzerland, Italy and the UK, and was a Getty Research Scholar (2016–17). He has excavated in Egypt since 1990 and currently directs the Qubbet el-Hawa Research Project. His publications include *100 Treasures / 100 Emotions* (2021).

Dr Keagan Brewer is a Macquarie University Research Associate, who specialises in the intersection between beliefs, disbeliefs and emotions in medieval Europe. He enjoys working on textual editions and translations. He has published multiple volumes in Routledge's *Crusade Texts in Translation* series, including on the Prester John legend.

Louise D'Arcens is Professor of English at Macquarie University. Her publications include *Comic Medievalism: Laughing at the Middle Ages* (2014), *Old Songs in the Timeless Land: Medievalism in Australian Literature 1840–1910* (2011), *The Cambridge Companion to Medievalism* (2016) and *World Medievalism: The Middle Ages in Global Textual Cultures* (forthcoming 2021).

Bronwen Neil FAHA is Professor of Ancient History at Macquarie University. She is an expert on Byzantine Greek and medieval literature, early Christianity and ancient letter collections in Greek and Latin. Her publications include *Dreams and Divination from Byzantium to Baghdad, 400–1000 CE* (2021).